LETTER FORMS

110 COMPLETE ALPHABETS

Frederick Lambert

LETTER FORMS
110 COMPLETE ALPHABETS

Edited by

Theodore Menten

DOVER PUBLICATIONS, INC., NEW YORK

Published in Canada by General Publishing Company, Ltd ,
30 Lesmill Road, Don Mills, Toronto, Ontario.
Published in the United Kingdom by Constable and Company,
Ltd., 10 Orange Street, London, WC 2.

This Dover edition, first published in 1972, is a revised republi-
cation of the work originally published as *Letter Forms* in London,
1964. The present edition is published by special arrangement with
the original publisher, Peter Owen, Ltd.

DOVER *Pictorial Archive* SERIES

Letter Forms: 110 Complete Alphabets belongs to the Dover
Pictorial Archive Series. Up to ten illustrations from this book
may be reproduced on any one project or in any single publication
free and without special permission. Wherever possible include a
credit line indicating the title of this book, author and publisher.
Please address the publisher for permission to make more exten-
sive use of illustrations in this book than that authorized above.
The republication of this book in whole is prohibited.

International Standard Book Number: 0-486-22872-X
Library of Congress Catalog Card Number: 70-182097

Manufactured in the United States of America
Dover Publications, Inc.
180 Varick Street
New York, N.Y. 10014

Introduction

Existing books on lettering usually fall into one of two categories: a collection of type faces that can often be found in a type specimen book, or letter forms designed by various artists for advertising. One of the constantly frustrating aspects of typefounders' specimens is that they rarely show complete alphabets, while books containing examples of advertising lettering also have their disadvantages. Few letter forms as conceived by the advertising lettering artist are better than similar designs available among existing type faces, and original lettering by these artists is normally confined to two or three words for a particular project or advertisement. As this is not intended to have lasting value, no complete alphabet is designed.

A book of letter forms in a large size and including all the letters of the alphabet can greatly facilitate the work of the designer.

At the present time there are nearly 6,000 type faces in existence. Many of these are familiar through widespread use but others, created to meet the growing needs of advertising design and frequently bad, have been discarded through changes in fashion.

A study of this large accumulation of alphabets is a stimulating experience and one that I believe would benefit many designers, typographers and students at present working with too limited a knowledge and appreciation of existing letter forms, which is in turn expressed by a limitation in much contemporary design. There is a trend towards "cold" functional typography that tends to activate against the more widespread use of many interesting and colorful type faces. Although broadly sympathizing with this I think that it can sometimes become a working formula inhibiting the creative use of type which expresses the essence of the written word. The wide diversity of content in printed matter demands more variety in contemporary typographic design and I hope that this book of over 100 alphabets will go some way towards achieving it.

My aim has been to compile a collection of alphabets that are well designed. Some of these are well known and widely used. I have also included many letter forms that are not so popular, but add richness and originality to our knowledge of lettering. These lettering designs have been compiled from the typefoundries of Great Britain, Europe and the U.S.A., and many of them are no longer produced. Some of the alphabets are original designs.

For all examples I have enlarged the alphabet beyond the largest size manufactured. Some designs possess capital letters only, and in several other instances I have omitted the small letters.

I hope that because of its variety of letter forms and practical format this book will aid the graphic designer, typographer and exhibition designer.

The following typefounders have supplied alphabets and granted permission to publish them:

American Type Founders Inc., Bauersche Giesserei, Fonderie Deberny & Peignot, Lettergieterij Joh. Enschedé en Zonen, Fonderie Typographique Française, Schriftgiesserei Genzsch & Heyse Ag, Haas'sche Schriftgiesserei Ag, Schriftgiesserei Gebrueder Klingspor, Ludlow Typograph Co., The Monotype Corporation Ltd., Fonderia Tipografica Società Nebiolo, Fonderie Olive, Schriftgiesserei D. Stempel Ag, Stephenson Blake & Co. Ltd., Stevens Shanks & Sons Ltd., Schriftgiesserei C. E. Weber.

Acknowledgement is also made to the designers who have permitted reproduction of their work.

F.L.

This 1972 American edition omits several complete alphabets and the lower case of several others, but adds more than ten upper-case alphabets of special interest to American designers. The type faces now occur in alphabetical order (Albertus, Antique No. 5, etc.), and the List of Alphabets gives the following information, where available:

Name of type face. Foundry (city), designer, year of design.

T.M.

List of Alphabets

1 Albertus. Monotype Corporation (Salfords, England), Berthold Wolpe, 1932.
2 Antique No. 5. Stevens Shanks & Sons (London), 1865.
3 Astoria. Bauersche Giesserei (Frankfurt/a/M), c. 1900.
4 Augustea. Società Nebiolo (Turin), A. Butti and A. Novarese, 1951.
5 Augustea Inline. Società Nebiolo (Turin), A. Butti and A. Novarese, 1951.
6 Banco. Fonderie Olive (Marseilles), Roger Excoffon, 1951.
7 Basalt. Genzsch & Heyse (Hamburg), E. Ege, 1927, 1934.
8 Baskerville. Monotype Corporation (Salfords, England), 1924. Based on designs by John Baskerville (1706–1775).
9 Baskerville Old Face. Stephenson Blake & Co. (Sheffield, England), Rowe Mores, 1768.
10 Beton Extra Bold. Bauersche Giesserei (Frankfurt/a/M), Heinrich Jost, 1935.
11 Bodoni Bold. Monotype Corporation (Salfords, England), 1928. Based on designs by Giambattista Bodoni (1740-1813).
12 Bookman. Miller & Richard (foundry no longer exists) and Mergenthaler Linotype (Brooklyn), c. 1936.
13 Broadway Engraved.
14 Caslon No. 540. American Type Founders (Elizabeth, N.J.). Based on designs by William Caslon (1692–1766).
15 Caslon No. 540 Italic. American Type Founders (Elizabeth, N.J.).
16 Century Expanded. American Type Founders (Elizabeth, N.J.), L. B. Benton, 1900.
17 Chisel. Stephenson Blake & Co. (Sheffield, England), Robert Harling, 1939.
18 Columna. Bauersche Giesserei (Frankfurt/a/M), Max Caflisch, 1955.
19 Craw Clarendon Bold. American Type Founders (Elizabeth, N.J.), Freeman Craw, 1955.
20 Craw Clarendon Book. American Type Founders (Elizabeth, N.J.), Freeman Craw, 1957.
21 Craw Clarendon Condensed. American Type Founders (Elizabeth, N.J.), Freeman Craw, 1959.
22 Craw Modern. American Type Founders (Elizabeth, N.J.), Freeman Craw, 1958.
23 Craw Modern Bold. American Type Founders (Elizabeth, N.J.), Freeman Craw, 1960.
24 Cristal. Deberny & Peignot (Paris), Remy Peignot, 1955.
25 Echo. Stephenson Blake & Co. (Sheffield, England), Peter Bell, 1956.

26 Egizio Condensed. Società Nebiolo (Turin), A. Novarese, 1958.

27 Egyptian Expanded Open. Stephenson Blake & Co. (Sheffield, England), 1958.

28 Egyptian, Halbfette [semibold, condensed]. German source, c. 1800.

29 Egyptienne, Breite [expanded]. German source, c. 1800.

30 Expanded Antique. Stevens Shanks & Sons (London), 1880.

31 Extra Ornamented No. 2. Stevens Shanks & Sons (London), c. 1900.

32 Falstaff. Monotype Corporation (Salfords, England), 1935.

33 Fanfare.

34 Festival. Monotype Corporation (Salfords, England), Phillip Boydell, 1951.

35 Folio Extra Bold. Bauersche Giesserei (Frankfurt/a/M), Konrad F. Bauer and Walter Baum, 1957–62.

36 Folio Medium. Bauersche Giesserei (Frankfurt/a/M), Konrad F. Bauer and Walter Baum, 1957.

37 Folio Medium Extended. Bauersche Giesserei (Frankfurt/a/M), Konrad F. Bauer, 1959.

38 Fontanesi. Società Nebiolo (Turin), A Novarese, 1954.

39 Fortune Light. Bauersche Giesserei (Frankfurt/a/M), Konrad F. Bauer and Walter Baum, 1955.

40 Fry's Ornamented. Stephenson Blake & Co. (Sheffield, England), Richard Austin, 1796.

41 Futura Black. Bauersche Giesserei (Frankfurt/a/M), Paul Renner, 1927–30.

42 Futura Inline. Bauersche Giesserei (Frankfurt/a/M), Paul Renner, 1927–30.

43 Futura Light. Bauersche Giesserei (Frankfurt/a/M), Paul Renner, 1927–30.

45 Gallia. American Type Founders (Elizabeth, N.J.).

46 Gotisch, Fette [bold Gothic]. Haas'sche Schriftgiesserei (Basel), 1860. The same character is used for capital I and capital J.

47 Grotesque Bold Condensed No. 4 Titling. Monotype Corporation (Salfords, England), 1939.

48 Grotesque No. 9. Stephenson Blake & Co. (Sheffield, England), 1906.

49 Grotesque No. 10. Stephenson Blake & Co. (Sheffield, England), 1880–1905.

50 Grotesque Outline. Letraset (London), 1962.

51 Information Extra Bold Wide. D. Stempel (Frankfurt/a/M), F. K. Sallwey, 1958.

52 Initiales. Joh. Enschedé en Zonen (Haarlem), P. Didot l'aîné, c. 1800.

53 Initiales Compactes Eclairées [three-dimensional capitals with black face]. Deberny & Peignot (Paris).

54 Initiales Ombrées [shaded capitals]. Deberny & Peignot (Paris), 1825.

55 Initiales Ordinaires. Deberny & Peignot (Paris), Emil Rudolf Weiss, 1937.

56 Italian Print.

57 Italienne, Breite [expanded]. German source, 1873.

58 Jonisch, Lichte [Ionic with white face]. German source, c. 1800.

59 Letter Form No. 2. Frederick Lambert, 1953.

60 Letter Form No. 4. Frederick Lambert, 1962.

61 Letter Form No. 6. Frederick Lambert, 1961.

62 Letter Form No. 7. Frederick Lambert, 1960.

63 Letter Form No. 9. Letraset (London), Frederick Lambert, 1962.

64 Lettres Ornées. Deberny & Peignot (Paris), 1820.

65 Macdonald. 1820.

66 Melior. D. Stempel (Frankfurt/a/M), Hermann Zapf, 1952.

67 Mercurius. Monotype Corporation (Salfords, England), Imre Reiner, 1957.

68 Michelangelo. D. Stempel (Frankfurt/a/M), Hermann Zapf, 1950.

69 Microgramma Bold Extended. Società Nebiolo (Turin), A. Butti and A. Novarese, 1952.

70 Microgramma Extended. Società Nebiolo (Turin), A. Butti and A. Novarese, 1952.

71 Modern No. 20. Stephenson Blake & Co. (Sheffield, England), 1905.

72 New Clarendon. Monotype Corporation (Salfords, England), 1960.

73 News Gothic. American Type Founders (Elizabeth, N.J.), Morris F. Benton, 1908.

74 News Gothic Bold. American Type Founders (Elizabeth, N.J.), 1958 (based on Benton's designs).

75 Ornamented Outline. Stevens Shanks & Sons (London), 1870.

76 Ornament Fleur de Lis. Circa 1900.

77 Perpetua Light Titling. Monotype Corporation (Salfords, England), Eric Gill, 1937.

78 Perpetua Titling. Monotype Corporation (Salfords, England), Eric Gill, 1928.

79 Phoebus. Deberny & Peignot (Paris), Adrian Frutiger, 1953.

80 Placard Bold. Monotype Corporation (Salfords, England), 1939.

81 Plantin. Monotype Corporation (Salfords, England), F. H. Pierpont, 1913.

82 Playbill. Stephenson Blake & Co. (Sheffield, England), Robert Harling, 1938.

83 Prisma. Klingspor (foundry no longer exists), 1931.

84 Profil. Haas'sche Schriftgiesserei (Basel), Eugen and Max Lenz, 1946.

85 Radiant Bold. Ludlow Typograph Co. (Chicago), R. H. Middleton, 1940.

86 Roman Initials. Frederick Lambert, 1955.

87 Roman Print Variously Shaded. Circa 1800.

88 Romantiques No. 5. Fonderie Typographique Française (Champigny), c. 1800.

89 Rundgotisch. Bauersche Giesserei (Frankfurt/a/M), 1903.

90 San Serif Shaded. Stephenson Blake & Co. (Sheffield, England), 1948.

91 Sans Stencil. Frederick Lambert, 1959.

92 Sapphire (Saphir). D. Stempel (Frankfurt/a/M), Hermann Zapf, 1953.

93 Slimblack. Deberny & Peignot (Paris), 1937.

94 Standard Medium. H. Berthold (Berlin), 1896.

95 Stencil. Ludlow Typograph Co. (Chicago), 1938.

96 Stradivarius. Bauersche Giesserei (Frankfurt/a/M), Imre Reiner, 1945.

97 Thorne Shaded. Stephenson Blake & Co. (Sheffield, England), 1938.

98 Times New Roman. Monotype Corporation (Salfords, England), Stanley Morison, 1932.

THE ALPHABETS

ABCD
EFGHIJK
LMNOP
QRST
UVW
XYZ

1 Albertus

A

BCDE

FGHIJK

LMNOP

QRSTU

VWXY

Z

ABCDEF
GHIJKL
MNOPQ
RSTUV
WXYZ
1234
567890

ABCDE
FGHIJ
KLMNOP
QRSTUV
WXYZ&!?
123456
7890

ABCDEF
GHIJKL
MNOPQ
RSTUV
WXYZ?!
&12345
67890

5 Augustea Inline

ABC
DEFGHIJK
LMNOPQR
STUVW
XYZ
&
123456789

6 Banco

ABCDEF
GHIJKL
MNOPQ
RSTUV
WXYZ
12345
67890

7 Basalt

ABCD
EFGHI
JKLM
NOPQR
STUV
WXYZ

ABCDEF
GHIJKL
MNOPQ
RSTUV
WXYZ
&
1234567890

9 Baskerville Old Face

ABCDE
FGHIJ
KLMN
OPQRS
TUVW
XYZ

ABC
DEFGHI
JKLMNO
PQRSTU
&VWXYZ

123456789

11 Bodoni Bold

ABC
DEFGHIJK
LMNOPQR
STUVW
XYZ
&
1234567890

ABCD
EFGHIJK
LMNOPQ
RSTUVW
XYZ
123
456789

13 Broadway Engraved

ABCD
EFGHIJK
LMNOPQ
RSTUVW
XYZ
&
123456789

14 Caslon No. 540

ABCD
EFGHIJK
LMNOPQR
STUVW
XYZ
&
1234567890

15 Caslon No. 540 Italic

A
BCDEFGHI
JKLMNOP
QRSTU
VWXYZ
1234567890
&
abcdefghijkl
mnopq
rstuvwxyz

16 Century Expanded

A

BCD

EFGHIJ

KLMNOP

QRSTUV

WXY

Z

ABCD
EFGHIJKL
MNNOPQ
RSTUV
WXYZ&12
34567890

ABCDEF
GHIJKL!
MNOPQ;:
RSTUV?
WXYZ&
$¢% 123
4567890

19 Craw Clarendon Bold

A
BCD
EFGHIJ
KLMNO
PQRST
UVWX
YZ

ABCDEFGH
IJKLMNOP
QRSTUVW
XYZ&?!¢$%
1234567890

21 Craw Clarendon Condensed

ABCDE
FGHIJKL
MNOPQ
RSTUV
WXYZ
&?!$123
4567890

ABCDEF
GHIJKL
MNOPQR
STUVWX
YZ-!?&
abcdefg
hijklmn
opqrstu
vwxyz:;

23 Craw Modern Bold

ABCD
EFGHIJK
LMNOPQ
RSTUVW
XYZ
123
4567890

24 Cristal

ABCDEFG
HIJKLMN
OPQRSTU
VWXYZ?&
123
4567890

ABCD
EFGH
IJKLM
NOPQ
RSTUV
WXYZ

&

ABC

DEFGH

IJKLM

NOPQ

RSTU

VWX

YZ

27 Egyptian Expanded Open

A
BCDEF
GHIJK
LMNOP
QRSTU
VWXY
Z

28 Egyptian, Halbfette

ABC
DEFGH
IJKLM
NOPQR
STUVW
XYZ
&
123
456789

29 Egyptienne, Breite

A

BCDE

FGHIJ

KLMN

OPQRS

TUVW

XYZ

&

1234
567890

ABCDEFG
HIJKLMN
OPQRSTU
VWXYZ&
1234567890

31 Extra Ornamented No. 2

ABCDEF
GHIJKL
MNOPQR
STUVWX
YZ £ &!?
123
456789

ABCDEF
GHIJKLM
NOPQR
STUVW
XYZ

12345678

ABCDEFG
HIJKLMN
OPQRST
UVWXYZ
& 1234
567890

ABCDEFG
HIJKLMN
OPQRSTU
VWXYZ&
abcdef
ghijkl;;
mnopq
rstuvw
xyzæœ

35 Folio Extra Bold

ABCD
EFGHIJK
LMNOPQ
RSTUV
WXYZ
&
123456789

36 Folio Medium

ABCDEFG
HIJKLMN
OPQRST
UVWXYZ
abcdefghi
jklmnopqr
stuvwxyz

37 Folio Medium Extended

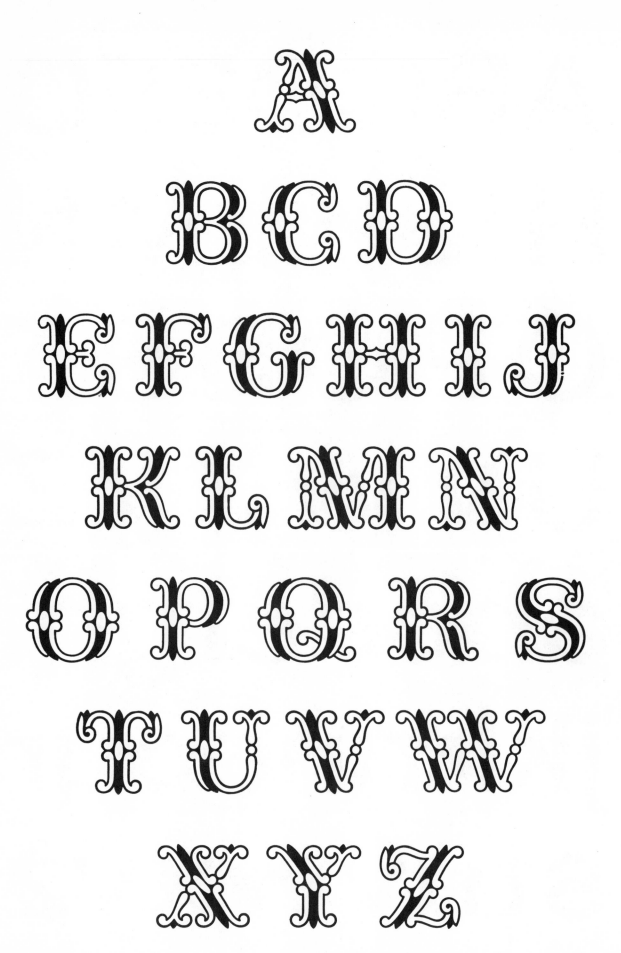

ABCDEF
GHIJKLM
NOPQRS
TUVW
XYZ
123
4567890

39 Fortune Light

ABCDE
FGHI
JKLMN
OPQR
STUVW
XYZ
&

ABCDEFG
HIJKLMN
OPQRST
UVWXYZ
abcdefghij
klmnopqrs
tuvwxyz

41 Futura Black

ABC
DEFGHIJK
LMNOPQR
STUVW
XYZ
&
123456789

42 Futura Inline

ABC
DEFGHIJK
LMNOPQR
STUVW
XYZ
&
123456789

43 Futura Light

ABCD
EFGHIJKL
MNOPQR
STUVW
XYZ
&
123456789

ABCD
EFGHIJK
LMNOPQ
RSTUV
WXYZ
123
456789

45 Gallia

ABCDEF
GHIKLM
NOPQRS
TUVWXY
Z
abcdefghijk
lmnopqrstu
vwxyz

46 Gotisch, Fette [bold Gothic]

ABCDEFG
HIJKLMN
OPQRSTU
VWXYZ!
?£ 123
4567890

47 Grotesque Bold Condensed No. 4 Titling

ABCDEFGH
IJKLMNOP
QRSTUVW
XYZ
&
123
4567890

ABC
DEFGHIJ
KLMNOPQ
RSTUVW
XYZ
&
123456789

49 Grotesque No. 10

ABCDEFGH
IJKLMNOP
QRSTUVW
XYZ&$£?!
123456789

ABCDE
FGHIJK
LMNOP
QRSTU
VWXYZ
123
456789

ABC
DEFG
HIJKLM
NOPQR
STUVW
XYZ

ABC
DEFGH
IJKLM
NOPQR
STUVW
XYZ

ABC
DEFGHIJ
KLM
NOPQR
STU
VWXYZ
1234567889

54 Initiales Ombrées`

ABCDEF
GHIJKLM
NOPQR
STUVW
XYZ1234
567890

ABCD
EFGH
IJKLM
NOPQ
RSTU
VWXX
YZ

57 Italienne, Breite

ABCDE
FGHIJK
LMNOP
QRSTU
VWXYZ

A B C
D E F G H
I J K L
M N O
P Q R S
T U V W
X Y Z

59 Letter Form No. 2

A
BCDEF
GHIJKL
MNOPQ
RSTUV
WXYZ
&
123
456789

ABCDE
FGHIJK
LMNOP
QRSTU
VWXYZ
&!?123
456789

61 Letter Form No. 6

ABCDEF
GHIJKL
MNOPQ
RSTUV
WXYZ
&
123
456789

ABCDEFG
HIJKLMN
OPQRSTU
VWXYZab
cdefghijk
lmnopqrs
tuvwxyz:

63 Letter Form No. 9

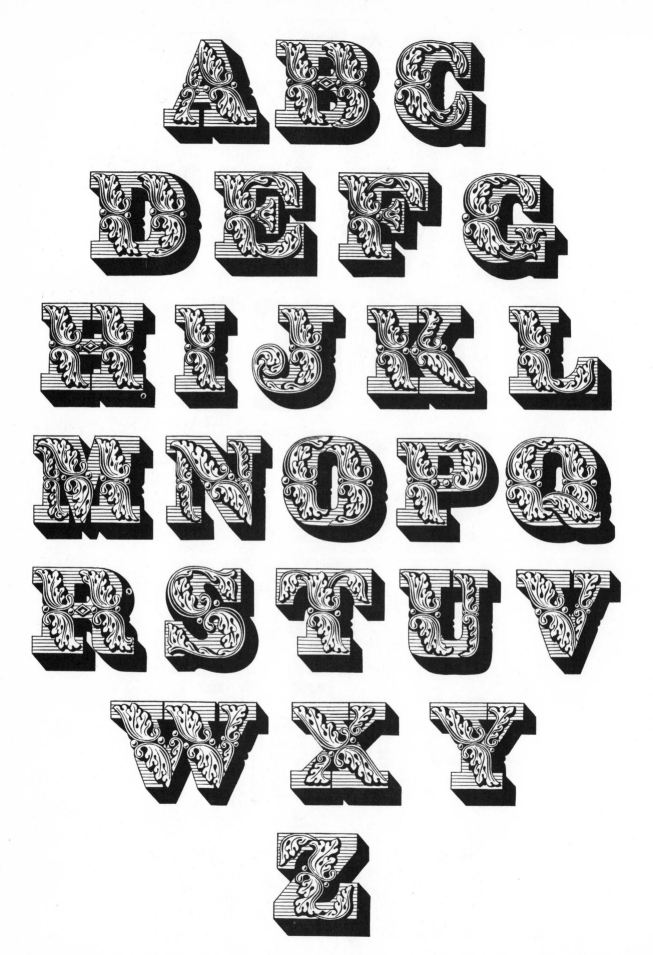

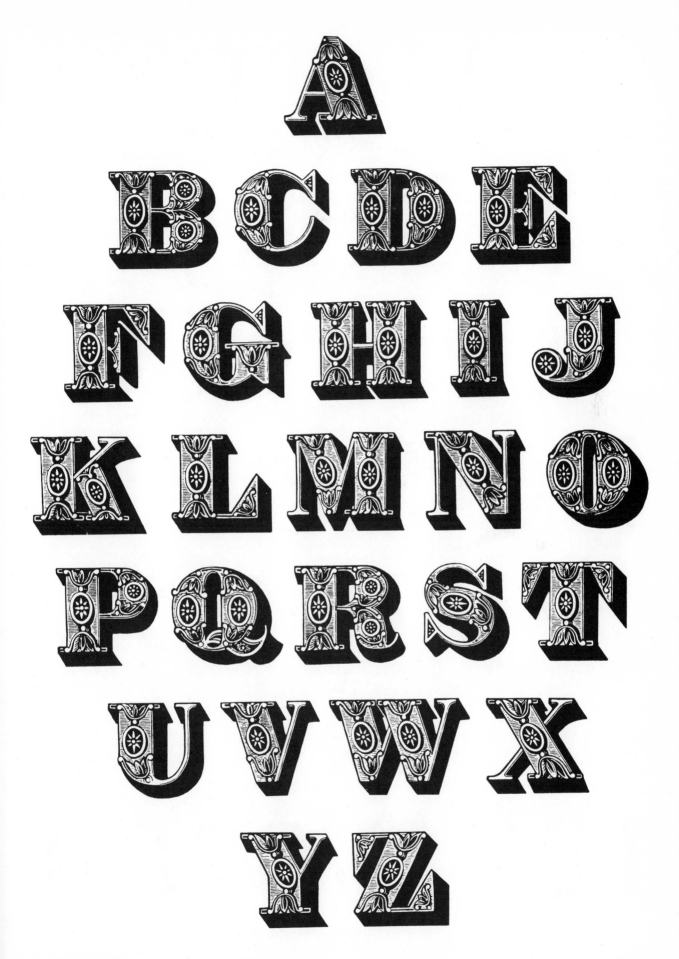

ABCD
EFGHIJK
LMNO
PQRSTU
VWXYZ
&
123456789

ABCDEF
GHIJKL
MNOPQR
STUVW
XYZ
1234567890

67 Mercurius

ABCDEF
GHIJKL
MNOPQ
RSTUV
WXYZ&
123456789

68 Michelangelo

ABCDE
FGHIJK
LMNOP
QRSTU
VWXY!
Z12345
67890?
&

69 Microgramma Bold Extended

ABCDEFG
HIJKLMN
OPQRSTU
VWXYZ&
?!$0C123
4567890

ABCDEFGH
IJKLMNOP
QRSTUVW
XYZÆÆŒ&?!
£1234567890

71 Modern No. 20

ABC
DEFGHI
JKLMNO
PQRSTU
VWXYZ
&123
4567890

ABCDE
FGHIJKL
MNOPQR
STUVWXY
Z&!!? 123
4567890

ABC
DEFGHIJK
LMNOPQ
RSTUVW
XYZ
123
456789

74 News Gothic Bold

ABCDEF
GHIJK
LMNOPQRST
UVW
XYZÆŒ
1234567890
&;?!

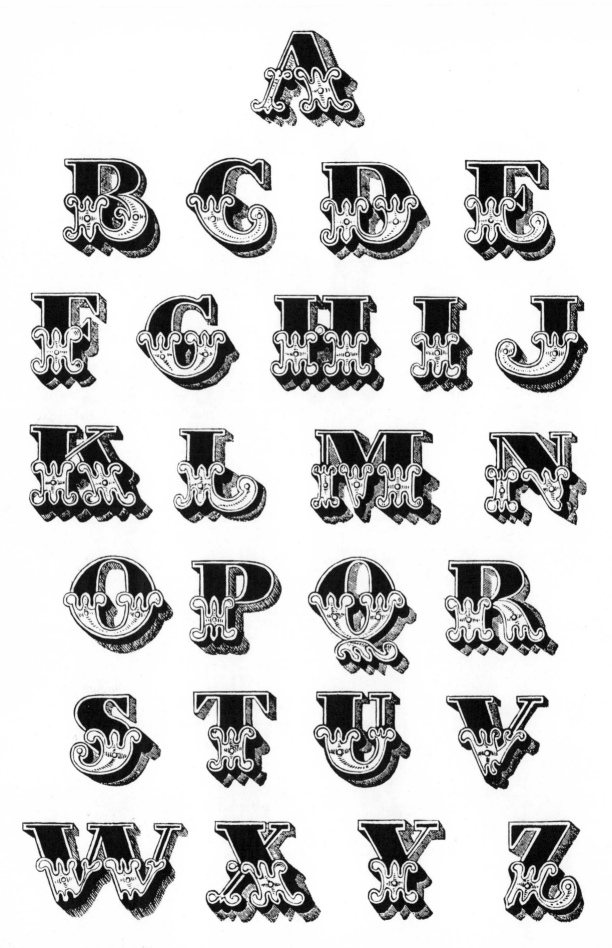

ABCDEFG
HIJKLMN
OPQRSTU
VWXYZ
&
1234
567890

77 Perpetua Light Titling

ABCDEF
GHIJKL
MNOPQR
STUVW
XYZ
&123
456789

78 Perpetua Titling

ABCDEFG
HIJKLMM
NNOPQRS
TUVWXY
Z&!?123
4567890

ABCDEFG
HIJKLMN
OPQRST
UVWXYZ
&
123
4567890

ABCD
EFGHI
JKLMNO
PQRSTU
VWXYZ
&
123456789

ABCDEF
GHIJKLM
NOPQRS
TUVWXYZ
&
123456789

ABCD
EF GHIJKL
MNOPQR
TSUVW
XYZ
&
123456789

ABCDEF
GHIJKL
MNOPQR
STUVW
XYZ123
4567890

A
BCDEFGHI
JKLMNOPQ
RSTUVWXY
Z
1234567890

ABCDE
FGHIJK
LMNOP
QRSTU
VWXYZ

ABCD
EFGHI
JKLMN
OPQRS
TUVW
XYZ

87 Roman Print Variously Shaded

ABCDEF
GHIJK
LMNOP
QRSTU
VWXY
Z

ABCD
EFGHIJKL
MNOPQRS
TUVWXYZ
abcde
fghijklmnop
qrstuvwryz

89 Rundgotisch

ABCDEFG

HIJKLMN

OPQRSTU

VWXYZ &

123

4567890

ABCDEFG
HIJKLMNO
PQRSTUV
WXYZ?&
12345
67890

91 Sans Stencil

ABCDEF
GHIJKL
MNOPQ
RSTUV?!
WXYZÆ
$1234&
567890

92 Sapphire (Saphir)

ABCDEFGH
IJKLMNOP
QRSTUVW
XYZ&£12
34567890

93 Slimblack

ABCDEFG
HIJKLMNO
PQRSTUV
WXYZ&12
34567890
abcdefghi
jklmnopqr
stuvwxyz

ABCDE
FGHIJK
LMNOP
QRSTUV
WXYZ
1234
567890

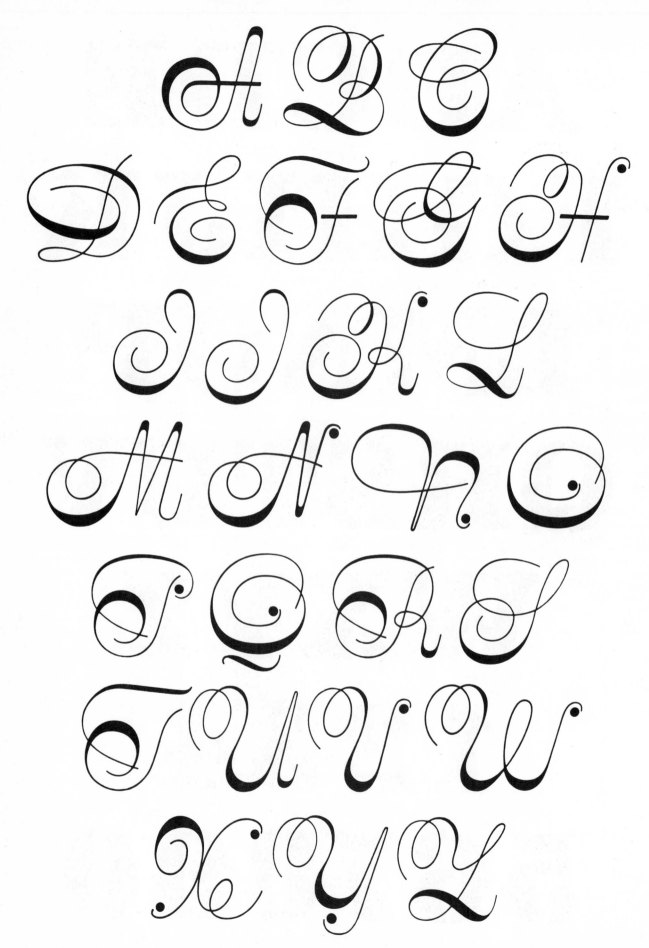

ABCD
EFGHIJ
KLMNOP
QRSTUV
WXYZ
123
456789

97 Thorne Shaded

ABCDEFGH
IJKLMNOP
QRSTUVW
XYZ&!?
£$1234567890
abcdefghijk
lmnopqrstu
vwxyz;:

ABC
DEFG
HIJKLM
NOPQRS
TUVW
XYZ

ABCDEF
GHIJKL
MNOPQ
RSTUVW
XYZ

abcdefgh
ijklmnopq
rstuvwxyz

A
BCDE
FGHIJK
LMNOP
QRSTU
VWXY
Z

101 Trump-Mediaeval (Trump-Mediäval) Medium

ABCDEF
GHIJKLM
NOPQRS
TUVWXY
Z
a
bcdefghij
klmnopqr
stuvwxyz

ABCD
EFGHIJK
LMNOPQ
RSTUVW
XYZ
123
456789

ABCDEF
GHIJKLMN
OPQRSTU
VWXYZ
abcd
efghijkl
mno
pqrstuv
wxyz

104 Vendôme

ABCDE
FGHIJK
LMNOP
QRSTU&
VW abcd
XY efghi
Z jklm;
nopq
rstuv
wxyz

105 Venus Extra Bold Extended

ABCDEFG
HIJKLMN
OPQRST
UVWXYZ
abcdefghij
klmnopqrst
uvwxyzæœ

106 Venus Medium Extended

A
BCD
EFGHIJ
KLMNOP
QRSTUV
WXY
Z

107 Victoria Bold Condensed

ABC
DEFGHIJK
LMNOPQR
STUVW
XYZ
&
123456789

ABCDEF
GHIJKL
MNOPQ
RSTUVW
XYZTh£$
1234567890&

109 Weiss Italic

ABCDEFGHIJ
KLMNOPQRS
TUVWXYZ
·AEKMNR·
abcdefghijklmno
pqrstuvwxyz
1234567890

110 Zeppelin